BIRKENHEAD

HISTORY TOUR

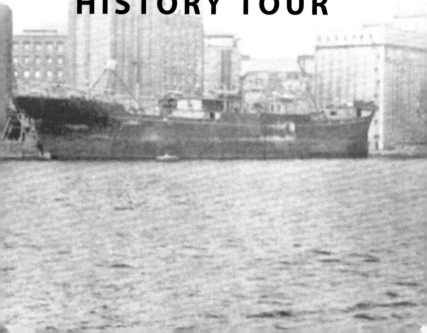

First published 2019

Amberley Publishing
The Hill, Stroud,
Gloucestershire, GL5 4EP
www.amberley-books.com

Copyright © Ian Collard, 2019
Map contains Ordnance Survey data
© Crown copyright and database
right [2019]

The right of Ian Collard to be
identified as the Author of this work
has been asserted in accordance with
the Copyrights, Designs and Patents
Act 1988.

ISBN 978 1 4456 8527 4 (print)
ISBN 978 1 4456 8528 1 (ebook)

British Library Cataloguing in
Publication Data.
A catalogue record for this book is
available from the British Library.

Origination by Amberley Publishing.
Printed in Great Britain.

INTRODUCTION

A Benedictine priory was established on the Wirral Peninsula in 1150, on a headland of birch trees, when Hamon de Mascy granted lands to the Order of St Benedict. A number of Black Monks moved from Chester, becoming the first inhabitants of Birkenhead, which was described as the little headland of the birches.

The Benedictine monks were renowned for their hospitality to travellers and the priory was built next to a landing stage at the river near Woodside. However, by 1284 the road was diverted away from the ferry as the priory could not cope with the demands made on it by travellers and a petition was sent to Edward II informing him that they were burdened beyond their resources.

Houses were built to accommodate the travellers in 1318 and in the charter of 1330, Edward III granted the prior and priory of Birkenhead and their successors forever the passage over the arm of the sea and the right to make reasonable charges. Following the Dissolution of the Monasteries in 1536, the monks were forced to leave the priory and their lands were confiscated by the king and sold to Ralph Worsley, who became lord of the manor.

There were various disputes in the sixteenth and seventeenth centuries between the burgesses of Liverpool and the Powell family, who were the owners of the Woodside Ferry. However, when the Powell family died the estates were sold in 1694 to Alderman John Cleveland and a boathouse and quay were built at Woodside landing stage. Ownership of the land passed to the Price family in 1716.

In 1815 Francis Richard Price sold land fronting on to the river and the area was developed. The number of passengers travelling on the ferry increased and a paddle steamer was placed on the service from Woodside

to Liverpool. The chapter house and priory buildings were replaced by a new church.

The population continued to increase and in 1817 a new half-hourly ferry service from Tranmere to Queens Dock in south Liverpool was inaugurated and a steam ferry was later introduced on the Woodside service. The new services from Liverpool to the Wirral encouraged people and merchants to move to Birkenhead and the population of 200 in 1821 was doubled in the following two years.

In 1810 William Laird moved to Liverpool to help attract orders for his father's rope works in Greenock and soon became a director of two shipping companies. He was initially interested in a scheme to sail ships up the River Dee and cross the peninsula by canal to Birkenhead. With this in mind he purchased land and a survey carried out by Telford, Nimmo and Stevenson, civil engineers, in 1828 came to the conclusion that a two-lane canal would cost approximately £1,401,000 and £734,000 for a single-lane waterway. Liverpool Council, merchants and businessmen soon became alarmed at the prospect of this local competition, so they purchased large areas of land and the scheme was abandoned.

However, Laird bought land near Wallasey Pool at Vittoria Wharf and built a boiler house, which later became the Birkenhead Iron Works. The Great Western Railway and the London & North Western Railway were interested in gaining access to the Mersey Docks and when Sir John Tobin and John Askew purchased land they asked Thomas Telford to look at the possibility of building a port on the Wirral side of the river.

Gillespie Graham, an Edinburgh architect, was appointed by William Laird in 1826 to design and build Hamilton Square and the roads and buildings at the centre of the town. The census of 1831 showed a population of 2,569 inhabitants in Birkenhead and two years later an Act of Parliament was approved for 'paving, lighting, watching, cleansing and otherwise improving the Township of Birkenhead, and for regulating the Police and the establishment of a Market'. The Improvement Commissioners were established to raise £8,000 in rates and tolls.

William Laird's son, John, a trained solicitor, joined his company in 1828. In the 1830s they made the decision to build ships of iron not wood.

The *Rainbow* was the largest ever iron ship and was handed over to her owners by Laird in 1837. In 1840 the first iron-built ship for the British government was constructed. It was a 113-foot packet named *Dover* and was followed by an order for four gunboats for the Royal Navy. John Laird decided to build a frigate that was propelled by paddle wheels.

In 1835 the Woodside Ferry Company was formed to build a railway from Chester to Woodside, Birkenhead, but this plan was opposed by the Birkenhead and Monks Ferry Company and several landowners who later formed the Birkenhead & Chester Railway Company. The two schemes were discussed by the arbitration panel in Parliament and work on the Chester & Birkenhead Railway was started in 1838. The company purchased most of the shares of the Woodside Ferry Company and acquired the Monks Ferry Company for £25,000 in 1840.

The Improvement Commissioners took over responsibility for the Woodside Ferry in 1842 and the following year they drew up plans to build a dock system at Birkenhead. The foundation stone was laid by Sir Philip Egerton, Member of Parliament for Cheshire, on 23 October 1844, on the same day that Monks Ferry Station was opened. Egerton and Morpeth Docks were opened by the Dock Commissioners on 5 April 1847, followed by the Great Float, which was later divided into East and West Floats. Following complaints about the high costs of shipping goods through the Port of Liverpool, a royal commission was appointed, which recommended setting up a new body to be responsible for running the docks. On 1 January 1858 the Mersey Docks and Harbour Board took over the operation of the docks at Liverpool and Birkenhead and John Laird was appointed as a nominee of the government.

Birkenhead Park was designed by Joseph Paxton and was also opened on 5 April 1847. Birkenhead was the first town to ask Parliament for the powers to build a park. American landscape architect Frederick Law Olmsted visited the park in 1850 and it influenced his design for Central Park in New York.

The Birkenhead Street Tramway was established in 1860. It operated from Woodside Ferry to Birkenhead Park and was the first street tramway to operate in Europe.

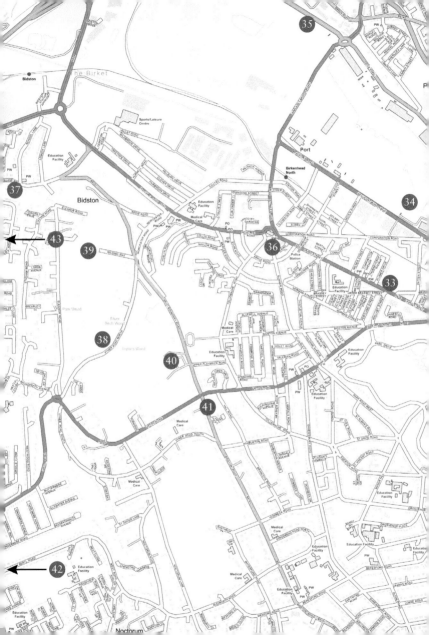

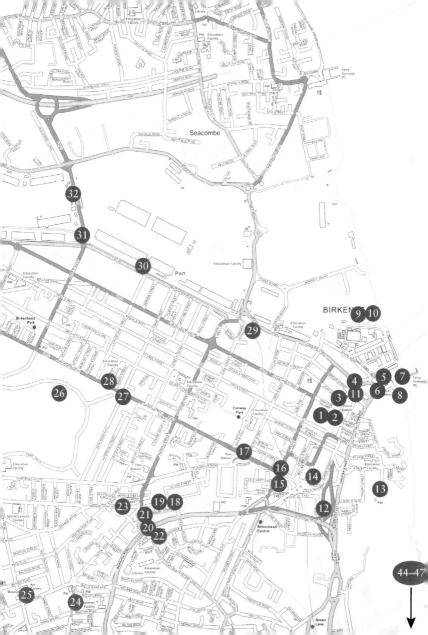

1. HAMILTON SQUARE

Hamilton Square was designed by the Edinburgh architect James Gillespie Graham and was named after the family of the wife of William Laird. Gillespie's design involved long and straight avenues with elegant town houses, and work commenced in 1825. However, lack of finance meant that Hamilton Square was the only part of the plan to survive and a plot was left empty for a town hall. In 1835 this area was used to establish the town's first market and ten years later a much larger market was opened nearby.

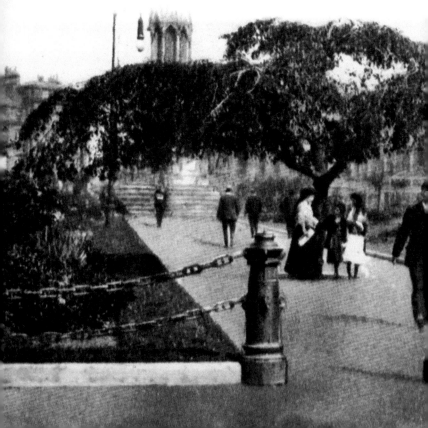

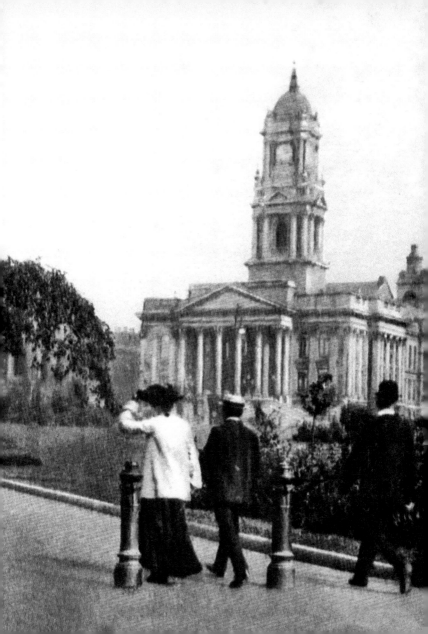

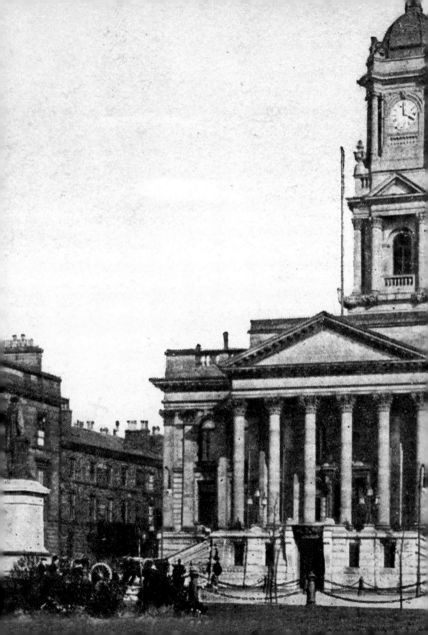

2. BIRKENHEAD TOWN HALL

Birkenhead Town Hall is the former civic building in Birkenhead and was originally the administrative headquarters of the County Borough of Birkenhead and more recently council offices for the Metropolitan Borough of Wirral. The building was completed in 1887 and was designed by local architect Christopher Ellison. It was constructed using Scottish granite and sandstone from the local quarry at Storeton. Birkenhead magistrates' court chambers are located to the rear. The clock tower is 200 feet in height and consists of four faces. The upper part of the clock tower was rebuilt in 1901, after suffering fire damage.

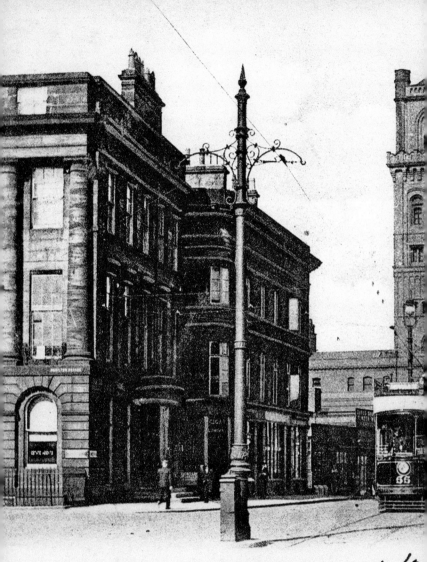

The Mersey Tunnel Tower, Birkenhead 14/2

3. HAMILTON SQUARE RAILWAY STATION

Parliamentary authority was obtained in 1871 for the construction of a double-track railway from Liverpool to the Wirral. However, it then took a further nine years for funds to be obtained to begin the project. When the initial contractor experienced financial difficulties a contract was given to Major Samuel Isaac, who made his fortune from work during the Crimean War. Colonel Beaumont of the Royal Engineers devised a boring machine and picks and shovels were used in the construction of the main tunnel.

The Prince of Wales opened the line from James Street in Liverpool to Hamilton Square and Green Lane in 1886. The track was extended to Birkenhead Park, West Kirby, New Brighton in 1888, and Rock Ferry in 1891, and the following year Central station, in Liverpool city centre, was opened. The trains were propelled by steam engines initially, with the steam and smoke polluting the underground stations. The railway was on the verge of bankruptcy due to the low patronage caused by the choking atmosphere created by the steam engines. However, in 1903 the system was electrified, becoming the world's first electric railway.

38

Valentines Series

ǧenaïde Gras

4. SHORE ROAD PUMPING STATION

Shore Road Pumping Station at Woodside contained the pumps that removed water from the Mersey Railway tunnel. It was built in the 1870s and the pumps were originally driven by steam beam engines. These were later replaced by electric pumps but one of the original pumps, the Giant Grasshopper, remains on display. However, the museum has now been closed to the public.

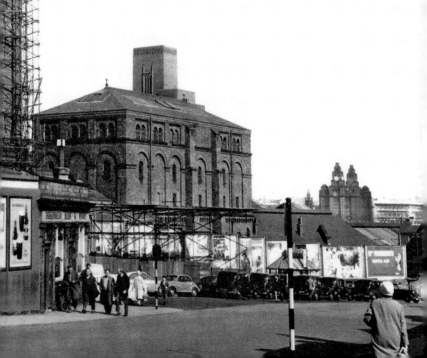

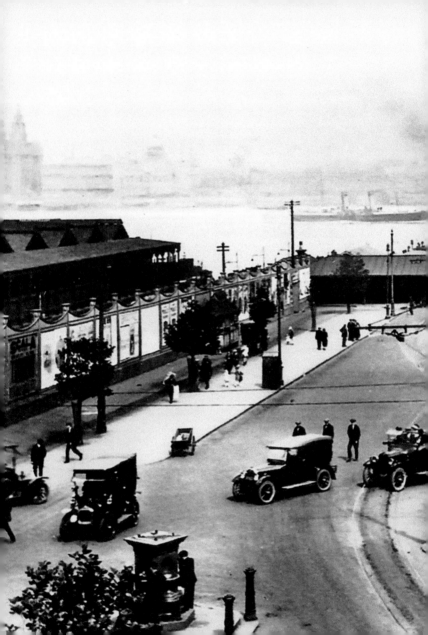

5. WOODSIDE FERRY AND TRAM STATION

As a wooden construction on brick foundations, the 1864 booking hall is a listed building. It remains unaltered, and was refurbished from 1985 in the original style, with many of the original timbers being replaced.

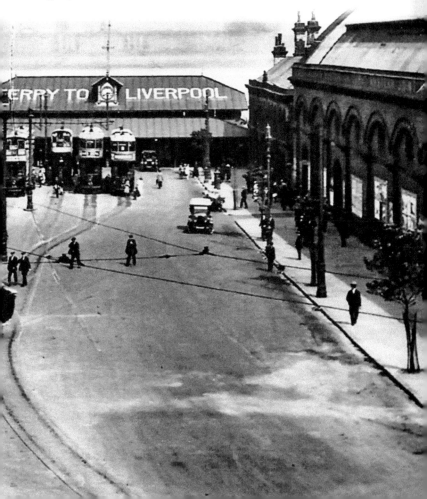

6. WOODSIDE STATION

The station at Monks Ferry was closed in 1878 and the passenger services were transferred to Woodside station. The station was opened on 1 April that year when it became the terminus for the Birkenhead to Chester line. Work on the Chester & Birkenhead Railway began in 1838 and a single line was opened in September 1840. The Birkenhead terminal was built in Grange Lane, which was an equal distance from Woodside, Monks Ferry and Woodside ferries. Woodside station survived until 6 November 1967. A section of the site is now a car park for buses. *Inset*: The train leaving Woodside station.

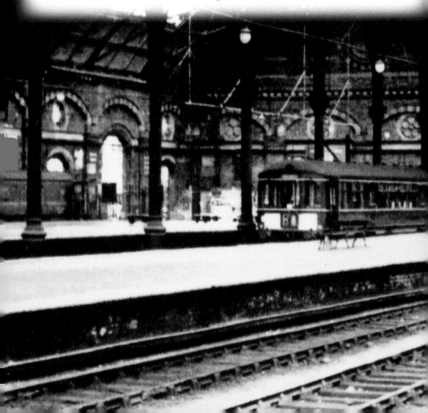

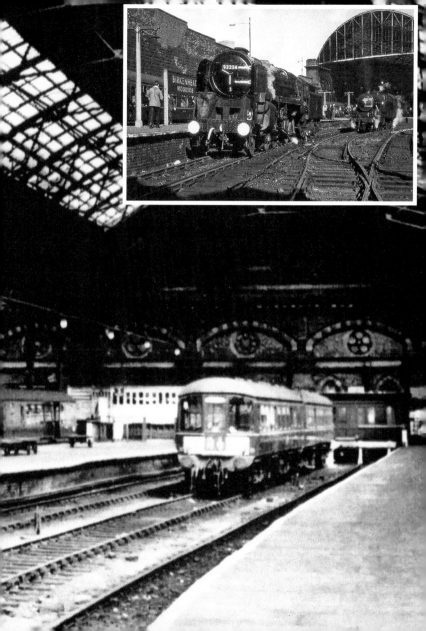

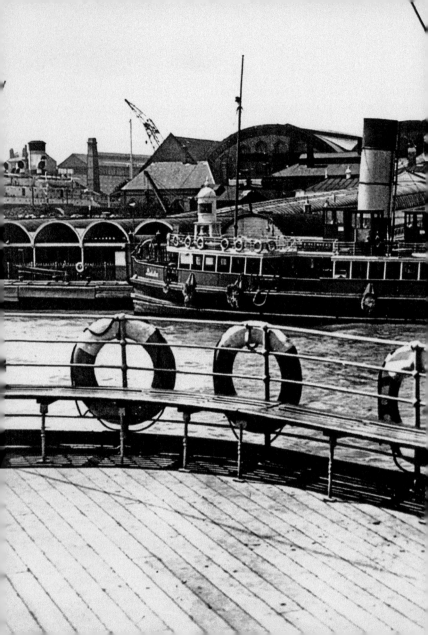

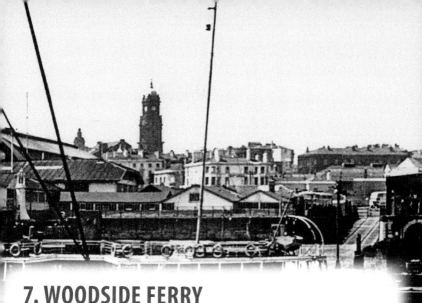

7. WOODSIDE FERRY

The floating stage was installed in 1862 and a floating roadway was built six years later to enable vehicles to travel across the river. However, the service had difficulty coping with the increasing demand in the early years of the twentieth century and it was announced that a vehicle tunnel would be built under the river. The Mersey Tunnel opened in 1934 and the vehicle ferry service was closed in 1939.

In 1990 Mersey ferries announced that the 'Ferry 'cross the Mersey' would be at the heart of the new range of services where 'passengers would be able to step on board at Liverpool Pier Head, Wallasey (Seacombe) or Birkenhead (Woodside) for a fascinating forty-five-minute river cruise'. A lively commentary brings to life the stories of the river and the ferries – the oldest of their kind in Europe – as well as the unfolding river scene, including, of course, one of the most memorable waterfronts. Passengers have the choice of staying on board for the round trip or getting off at Seacombe, Woodside or the Pier Head. There are now interesting attractions at all three terminals.

8. THE BUILDINGS AT GRAYSON, ROLLO DRY DOCKS, WOODSIDE

The shipyard was a repair and dry dock facility, situated on the riverfront at Woodside. It became Western Ship Repairers Ltd in the 1970s and was closed ten years later. The area has since been redeveloped with residential apartments, offices and small business units. A pedestrian walkway enables people to walk from Woodside to Monks Ferry and evidence of the ship-repair facilities is still visible.

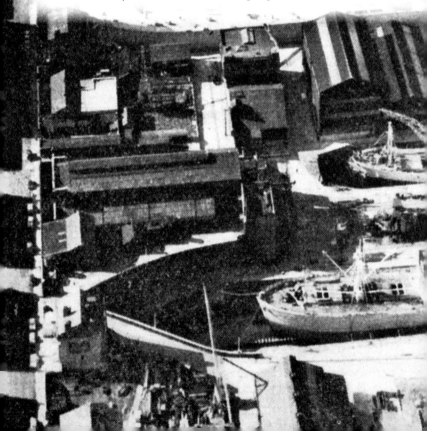

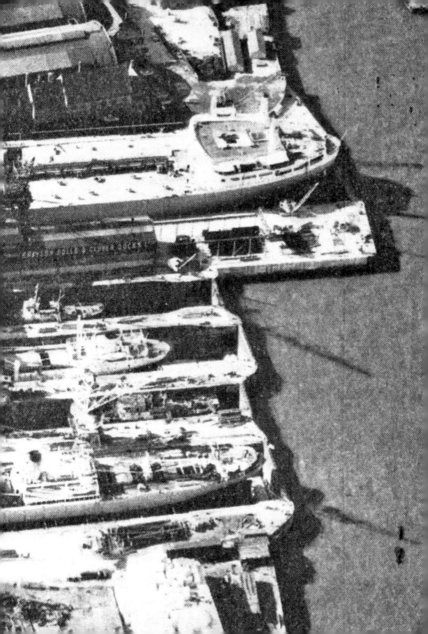

9. MORPETH DOCKS

The Birkenhead Docks Company was formed in 1847 and Egerton and Morpeth Docks were opened. Over the years, merchants became dissatisfied as they claimed that the dues paid were not being reinvested in the port and the docks. Following a royal commission in 1853 a bill was introduced in 1857 to create the Mersey Docks and Harbour Board, which was made responsible for the port facilities and was controlled by twenty-eight Dock Trustees.

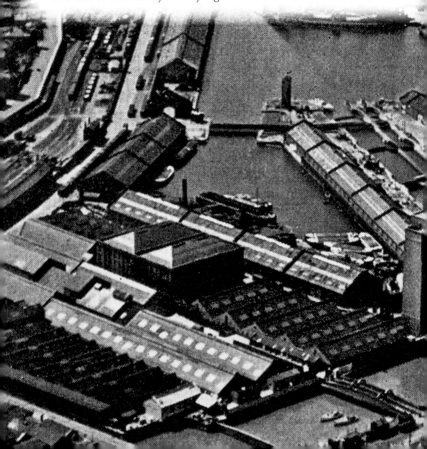

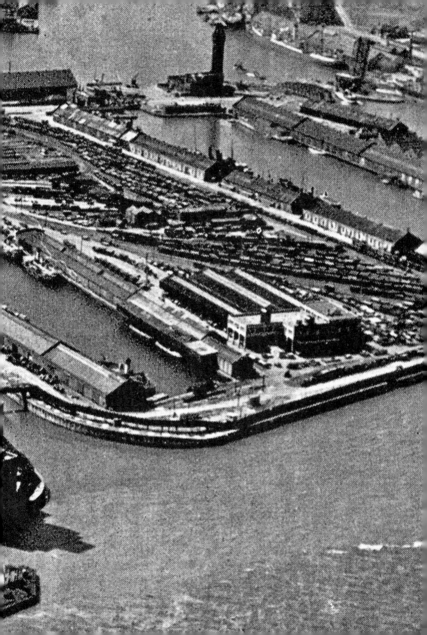

10. FIRING THE GUN

On 18 July 1969 the 102-year tradition of firing the gun at 12 o'clock ended. The Naval Hotchkiss gun at Morpeth Dock had been loaded by Mersey Docks and Harbour Board staff employed at nearby Woodside landing stage but restructuring meant that they were no longer available to carry out these duties. The actual firing had been by remote control from Liverpool University's Tidal Institute, better known as Bidston Observatory. The original cannon was a relic of the Crimean War and it was first proposed to discontinue the practice in 1932. This did not happen, although firing was suspended during the Second World War.

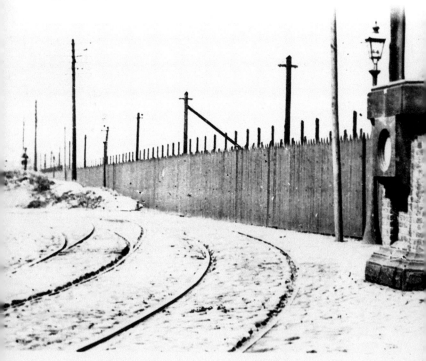

THE ONE O'CLOC

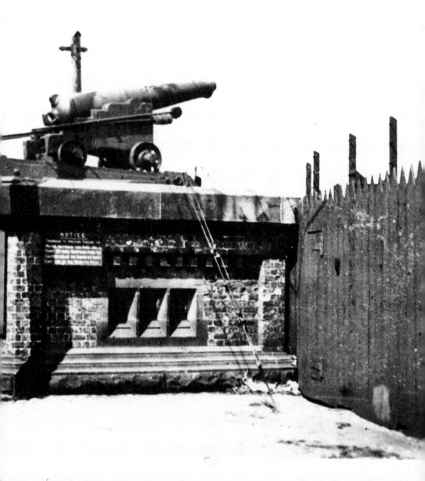

UN, BIRKENHEAD.

11. WOODSIDE BUS STATION LOOKING TOWARDS BIRKENHEAD TOWN HALL

Woodside railway station is on the left, with a Crosville bus leaving the terminal bound for Chester. The photograph is taken from the front of the Woodside Hotel, which was built in 1834 to replace an earlier building of the same name. It was damaged by fire on 4 June and 13 August 2008 and was declared structurally unsafe. The hotel was then demolished without planning permission in October that year.

12. MERSEY TUNNEL ENTRANCE AT BIRKENHEAD

In the 1920s it became clear that the vehicular ferries operating across the river were finding it difficult to cope with the level of traffic. A parliamentary bill was passed and Edmund Nuttal was appointed as the main contractor for the building of a tunnel from Liverpool to Birkenhead. By 1928 the two pilot tunnels met, and on completion of the project the tunnel was opened by King George V and Queen Mary on 18 July 1934.

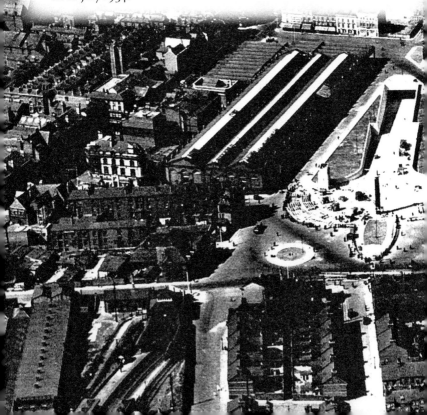

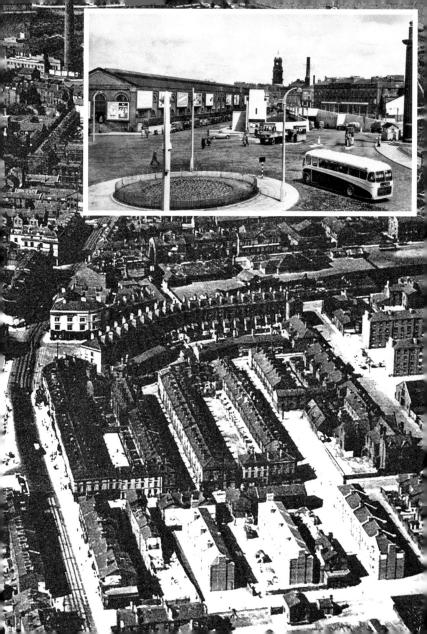

13. ST MARY'S CHURCH

St Mary's Church was built by Francis Price on land next to Birkenhead Priory. It was consecrated on 17 December 1821, transepts were added between 1832 and 1835, and further work was carried out in 1883. The demolition of residential properties around the church caused the congregation to move to other areas of the town, and it was decided to demolish the building in 1977. The spire of the church is still intact and services were held in the chapter house of the priory.

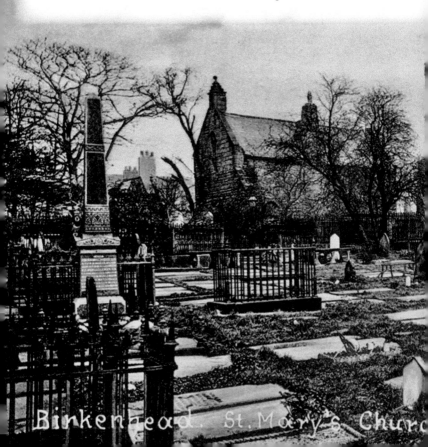

Birkenhead. St.Mary's Church

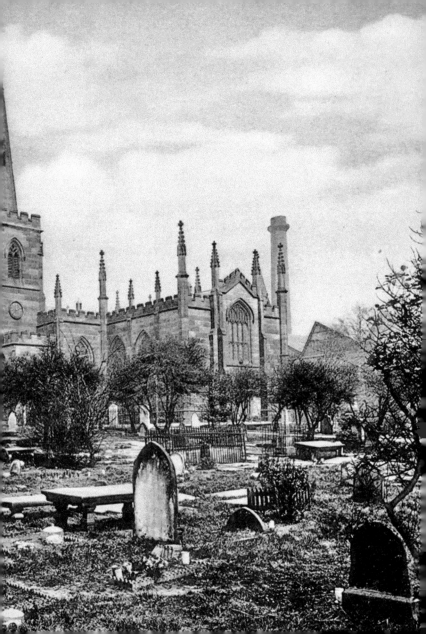

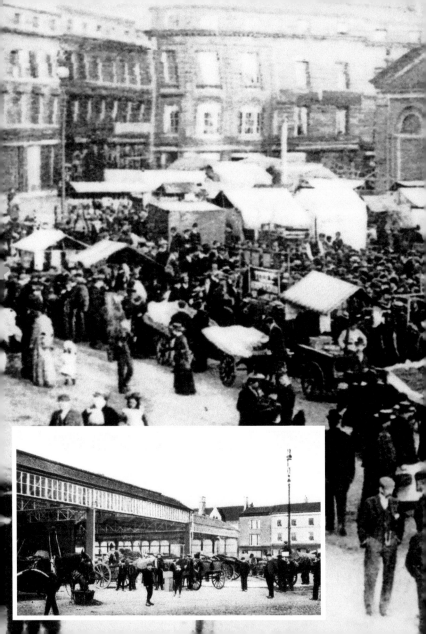

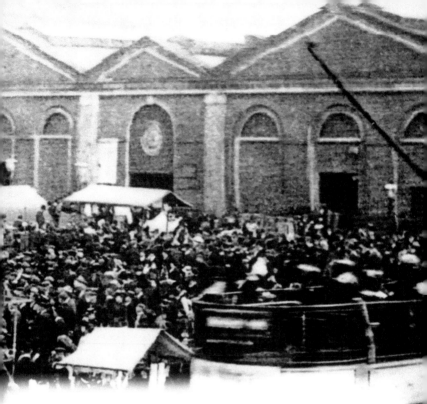

14. MARKET SQUARE, 1890

The market was opened on 12 July 1845, replacing one built ten years earlier. The work was completed by Fox, Henderson & Co., who later worked on the Crystal Palace. The building was 430 feet long and 131 feet wide, and was situated between Hamilton and Albion Street. The market housed forty-two shops and eighty stalls, and was constructed of brick, glass and iron with a wrought-iron roof, supported by cast-iron columns. The building was extended in 1909 and was partly destroyed by fire in 1974. A new market was later erected in 1977 near the shopping centre at Grange Road.

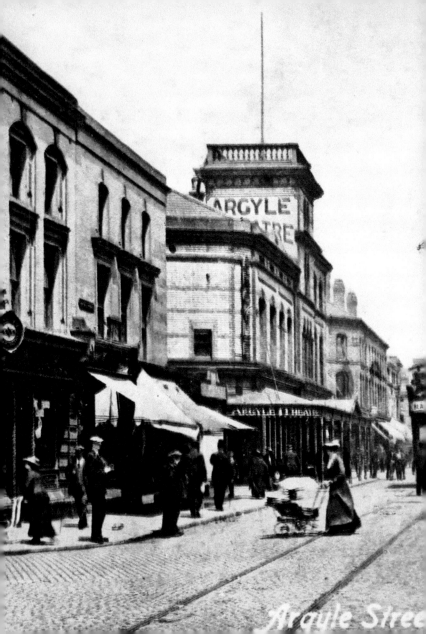

Argyle Stree

15. THE ARGYLE THEATRE AND HOTEL, ARGYLE STREET

The Argyle Theatre was opened on 21 December 1868 by Dennis Grennell and in 1876 it was named the Prince of Wales Theatre. However, when it was managed by Dennis J. Clarke between 1888 and 1934 the name Argyle was restored and it became one of the country's most famous music halls. Charlie Chaplin, W. C. Fields, G. H. Elliot, George Formby, Stan Laurel and Donald Peers all appeared on the stage at the theatre. On 21 September 1940 it took a direct hit from German bombers and was destroyed by fire.

16. CONWAY STREET

This image shows Conway Street *c*. 1930, with the Conway Arms on the left, which was situated on the corner of Claughton Road. The pub was demolished in the 1960s when the area was redeveloped and the tunnel flyover roads were constructed. The Empire Cinema was the last cinema in Birkenhead when it closed in 1991. The building next to C. Stephens, funeral director's, is the main post office, which was moved to Argyle Street in 1908. It became The Picture House and later The Super Cinema, and was one of the first venues for the group the Beatles in the 1960s. It later became a ballroom and furniture showroom and recently a restaurant. The building with the dome was the Birkenhead Higher Elementary Technical School.

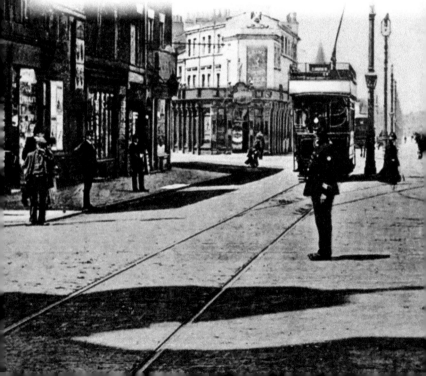

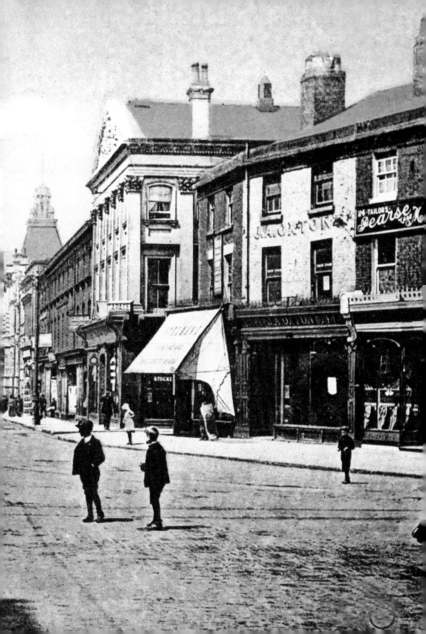

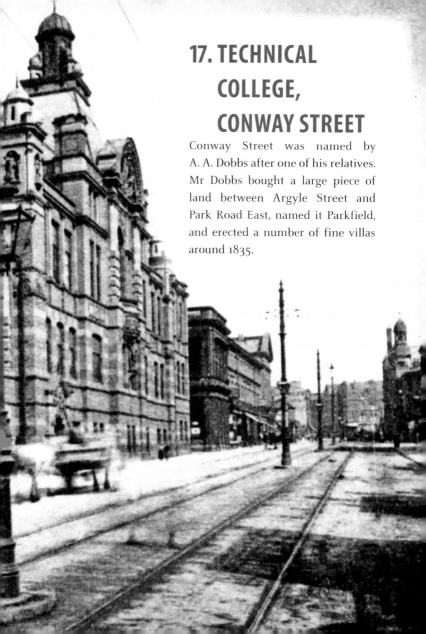

17. TECHNICAL COLLEGE, CONWAY STREET

Conway Street was named by A. A. Dobbs after one of his relatives. Mr Dobbs bought a large piece of land between Argyle Street and Park Road East, named it Parkfield, and erected a number of fine villas around 1835.

18. GRANGE ROAD

Grange Road is the main shopping centre in the Wirral. There are others at Liscard, Wallasey, Moreton, Upton, West Kirby, Hoylake and Bromborough.

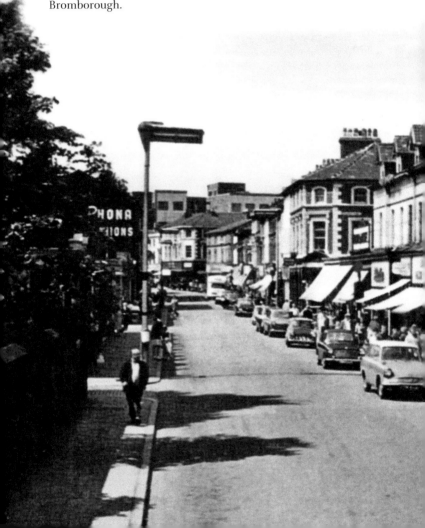

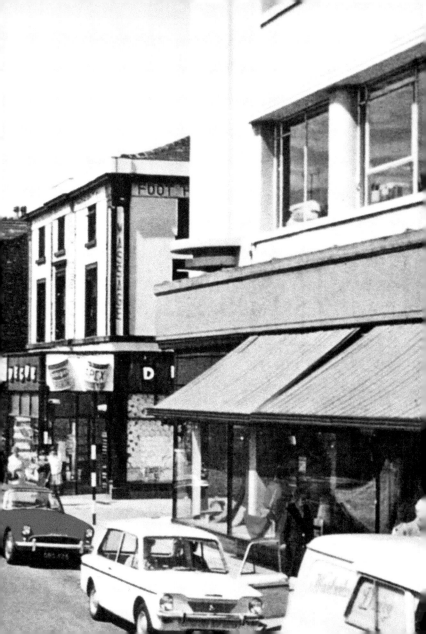

19. GRANGE ROAD AT THE JUNCTION WITH HORATIO STREET

The land was originally owned by John Somerville Jackson, who named a number of streets after military events. Horatio Street was named after Horatio Nelson and St Vincent Street commemorated a victory off Cape St Vincent, Portugal.

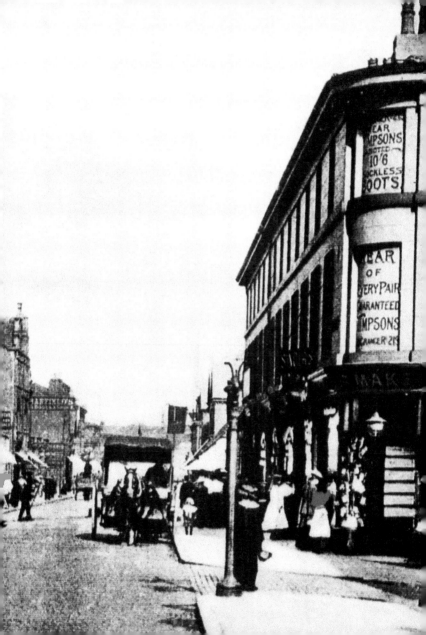

20. CHARING CROSS FROM BOROUGH ROAD

Charing Cross is one of the busiest road junctions for road traffic in Birkenhead.

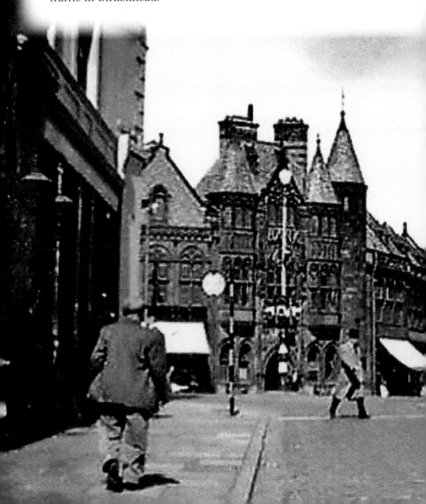

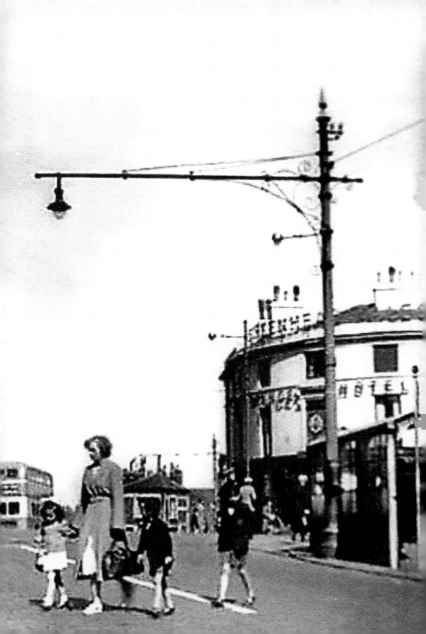

21. GRANGE ROAD FROM CHARING CROSS

The Birkenhead Brewery public house the Grange Hotel was built in 1840. The pub was closed in 1982, demolished and is now the site of a fast-food restaurant. Martins Bank, later Midland Bank, was built in 1901 and has now been converted into a bar. The roundabout has now vanished, being replaced by traffic lights.

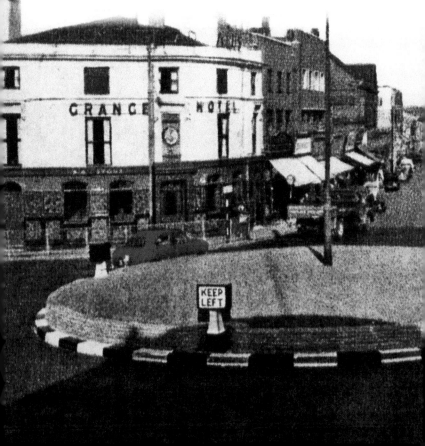

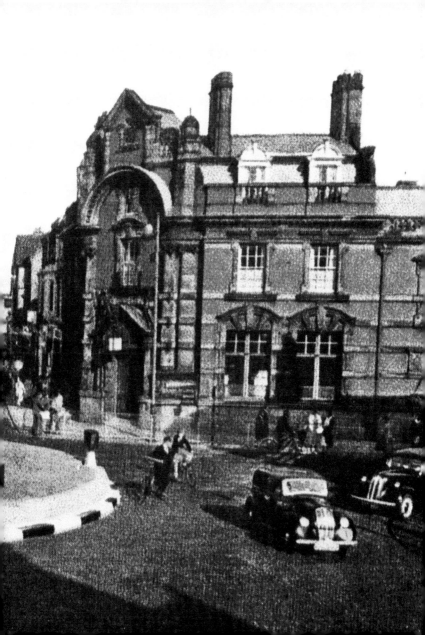

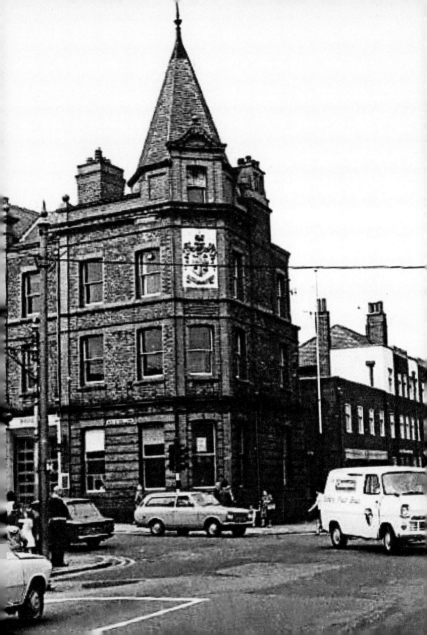

22. FIRE STATION, BOROUGH ROAD/ WHETSTONE LANE

The fire station was opened on 9 December 1895, replacing those at Hamilton Street and Dale Street. A telephone line was installed linking Whetstone Lane with the exchange, and two stations on Birkenhead Docks were also connected to the exchange. The fire service received ninety-five calls that year. In 1938 flats and two additional appliance bays were built on the site of the former stables fronting on to Borough Road at the side of the main station. Two additional bays were also added at the side of the main station on Whetstone Lane. A second block of three-storey flats was also built facing onto the yard with their back to Dale Street. The new Exmouth Street fire station was opened on 28 March 1973, replacing the seventy-eight-year-old Whetstone Lane station.

23. GRANGE ROAD WEST

The monks at Birkenhead Priory farmed the land and their nearest farm was at The Grange at Claughton. Grange Road, Grange Mount and Grange Road West led to the farm. The Little Theatre provides a variety of different entertainment. The Carlton Players were formed in 1930, and Birkenhead Dramatic Society began in 1906 and was managed by Harold Smith. The Birkenhead Operatic Society was founded in 1938 to entertain the troops, and in 1949 their first major production was *Rose Marie* at the theatre.

24. WIRRAL DISPENSARY

The Wirral Dispensary and Hospital for Sick Children was originally opened in Wilkinson Street in 1869, moving to Oxton Road in 1872 and to the Woodchurch Road site in 1883. From 1898 until just after the Second World War the hospital was known as the Birkenhead and Wirral Children's Hospital. It was supported by voluntary subscriptions until the formation of the National Health Service in 1948, when it came under the control of the Birkenhead HMC, and subsequently of the Wirral Area Health Authority in 1974. It closed in January 1982, when the services were transferred to the new Arrowe Park Hospital.

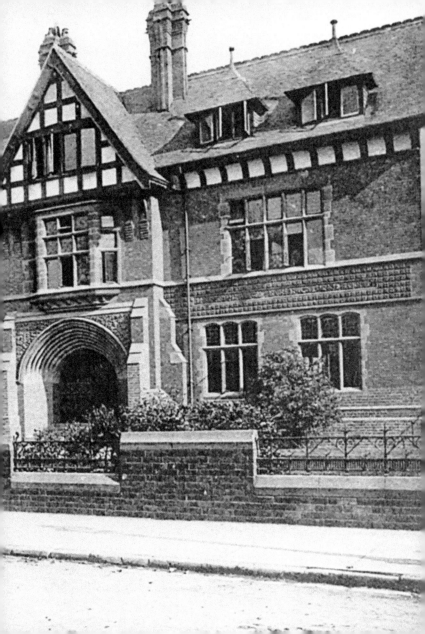

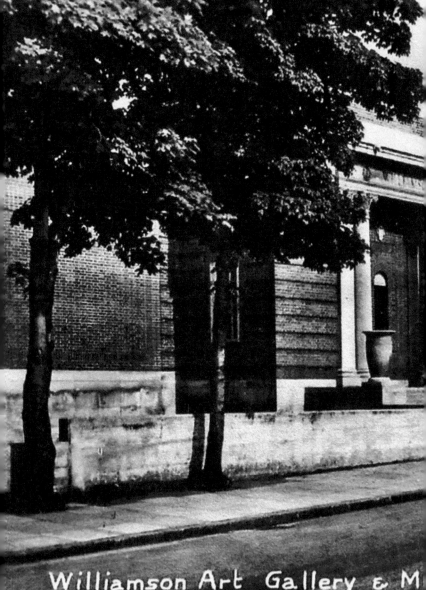
Williamson Art Gallery & M

25. WILLIAMSON ART GALLERY

The Williamson Art Gallery offers fourteen gallery spaces that host changing exhibitions of national and local significance. It also displays paintings by local artists, porcelain and Birkenhead's own contribution to the Arts and Crafts movement, the Della Robbia Pottery. The Maritime Gallery features ship models from the area, focusing on Cammell Laird Shipbuilders and their contribution to marine history, the Mersey Ferries. The Williamson Gift Shop features the work of local craftspeople, including potters, textile artists, jewellers and photographers.

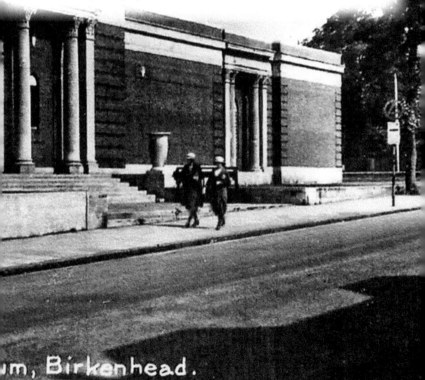

ım, Birkenhead.

26. SWISS BRIDGE, BIRKENHEAD PARK, 1950s

The bridge, a 23-foot pedestrian span of stringer construction, was built in 1847, and is the only covered bridge of traditional wooden construction (similar to North American and European covered bridges) in the United Kingdom. It was modelled after similar wooden bridges in Switzerland. It was subject to vandalism for several years and was restored and painted in its original colours in 2008 with help and assistance from the National Lottery Heritage Fund.

27. PARK ENTRANCE

The entrance gate in Birkenhead Park was designed by Lewis Hornblower and is on the junction where Park Road North meets Park Road East. The frontage measures 125 feet, with a central carriageway through an arch of 18 feet span, which is 43 feet in height. The original gates featured the armorial bearings of Birkenhead Priory.

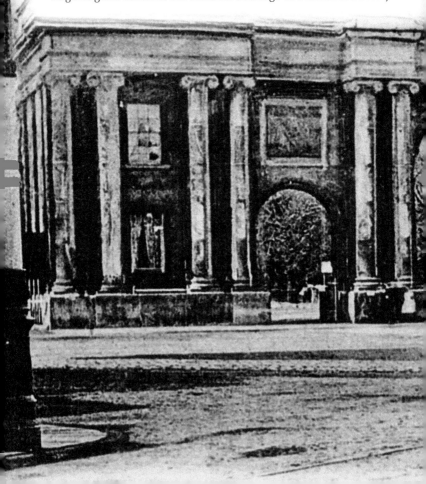

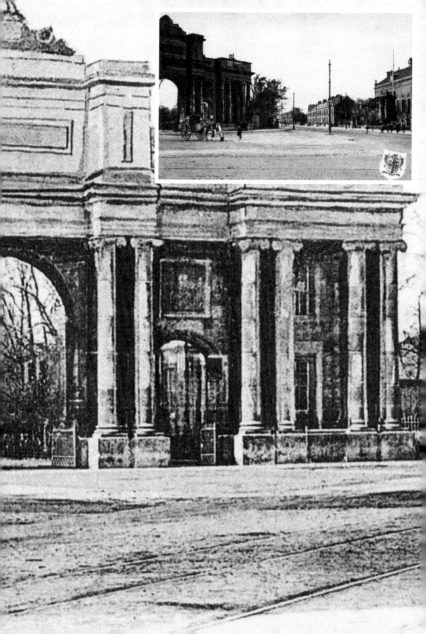

28. LAIRD SCHOOL OF ART

Laird School of Art in Park Road North was opened on 27 September 1871 and was the first public school of art outside London. It was given to the town by John Laird and operated until 1979, when it merged with the Birkenhead College of Technology in Borough Road.

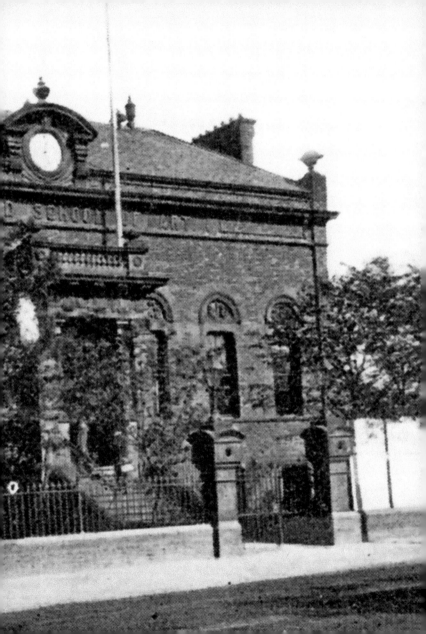

29. BIRKENHEAD DOCKS' FOUR BRIDGES

The Four Bridges connect Wallasey with Birkenhead. Most ships entering the dock system have to pass through the bridges to reach their loading/discharging berths.

30. VITTORIA DOCK AND VITTORIA WHARF ENTRANCE

The main entrances to the Vittoria Dock and Vittoria Wharf was from Corporation Road. In the late 1950s and 1960s several of the berths at Birkenhead Docks were rebuilt, old warehouses demolished and new sheds constructed. Vittoria Dock loading berths were completely redesigned and modern warehouses built for the Clan Line and Alfred Holt & Co. Ltd.

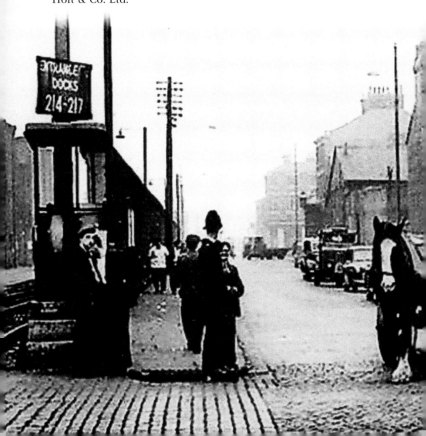

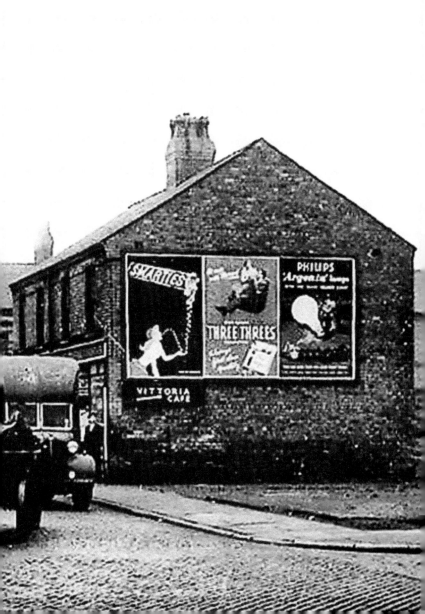

31. BIRKENHEAD DOCK ENTRANCE

The entrance to Birkenhead Docks at Duke Street in the 1960s when traffic was directed by a police officer in an elevated box.

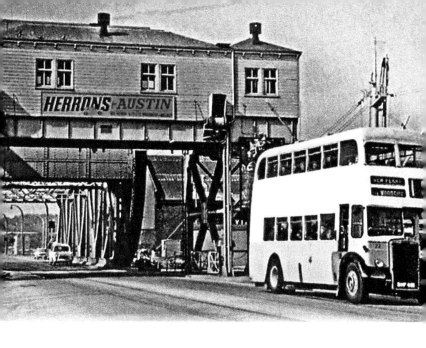

32. DUKE STREET BRIDGE

The No. 10 New Brighton to New Ferry via Woodside Wallasey Corporation bus at Duke Street Bridge.

33. LAIRD STREET TRAM TERMINUS, 1910

The Tramways Office was opened on 28 July 1903 following the introduction of the new electric trams and various routes across the borough. Forty-two trams could be stored at the depot and this was later extended to accommodate sixty vehicles. An extension was built in 1927 when the new buses were introduced and the depot is still used as the depot for Arriva plc, Wirral.

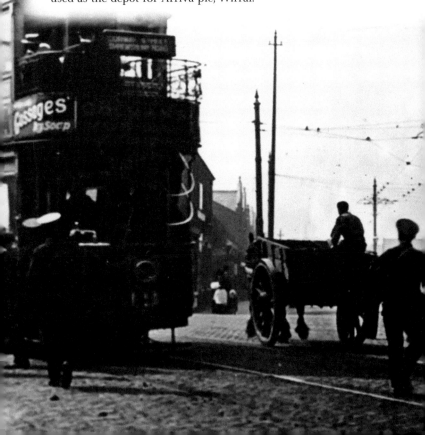

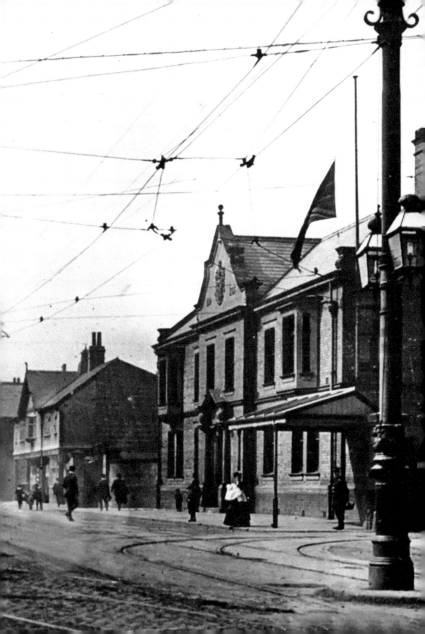

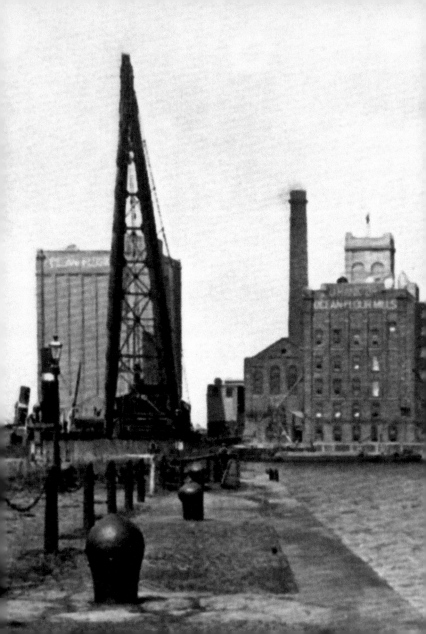

34. GRAIN WAREHOUSES, EAST FLOAT

In 1865 large grain warehouses were built at the East Float at Birkenhead, and in 1912 at the West Float, to deal with the increasing number of imports of grain from European and Black Sea ports and, later, North and South American, Indian and Baltic cargos. The grain was initially shipped by rail but by the end of the nineteenth century the milling companies converted many of the corn warehouses into milling facilities, which also bagged the flour. This flour was then usually sent by rail, and later road, to inland destinations.

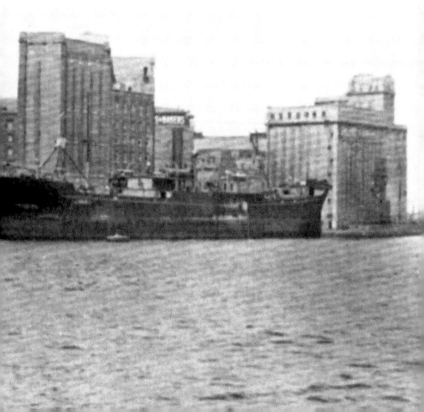

35. BIDSTON DOCKS IRON ORE DISCHARGING BERTH

Iron ore was imported through Birkenhead following the opening of steelworks in North Wales. The railway operators were able to utilise the empty coal wagons to transport the iron ore from the docks, which was used together with the Welsh coal and limestone to manufacture quality steel. Most of this material was transported from Rea's berth at Duke Street to John Summers works at Shotton. However, the trade increased to the extent that special unloading facilities were installed at Bidston Dock in 1950. The huge cranes were capable of lifting the iron ore from the ship to the railway wagons, which ran along the quayside. In 1954 the iron ore trade had increased to one million tons and by 1956 it had doubled to two million tons per year.

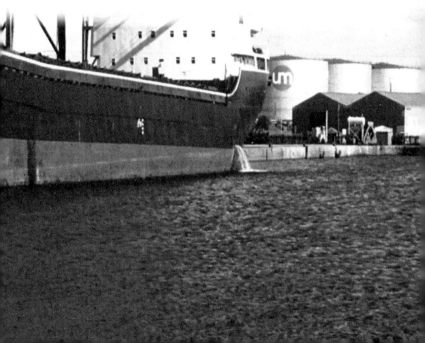

36. ST JAMES' CHURCH

St James' Church was opened in 1858 at the junction of Laird Street and Hoylake Road. It was built to serve the Dock Cottages. The cottages were provided by the Birkenhead Dock Company in 1845 to house the families of their workmen. Each block was four stories high and each flat was provided with fresh water. The cottages were originally named Queens Buildings and survived for a century before they were demolished and Ilchester Square was built on the site. The final section of Ilchester Square was demolished in 2009.

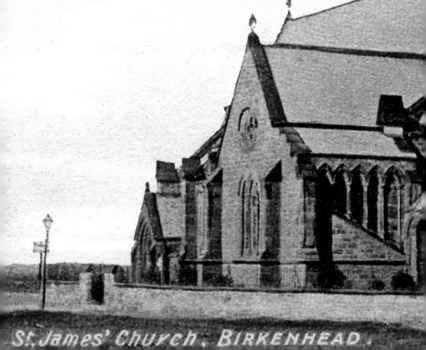

St. James' Church. BIRKENHEAD.

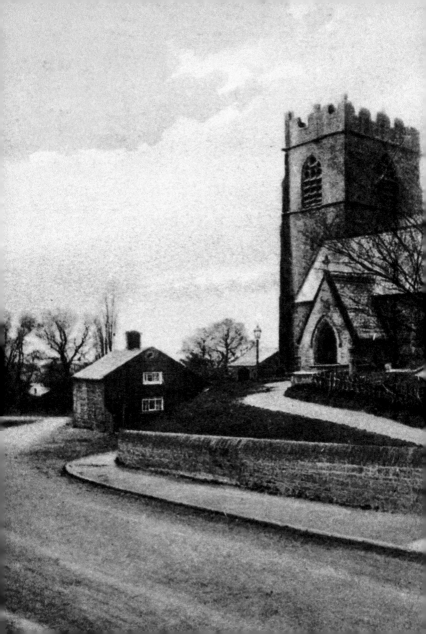

37. ST OSWALD'S CHURCH, BIDSTON, FROM SCHOOL LANE

A church has stood on this ground since the twelfth century and the tower dates from around 1520. It was rebuilt in 1856 and a sanctuary was added in 1882. One of the bells has the inscription St Oswald, and it is thought that it came from St Oswald's Church in Chester.

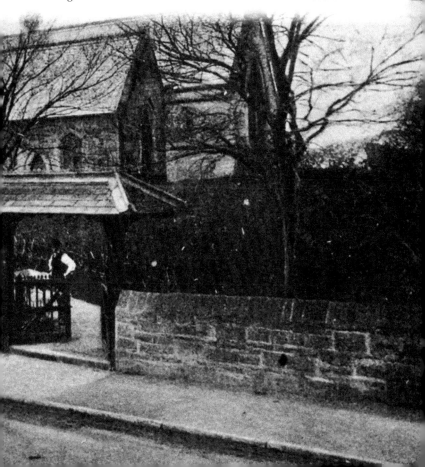

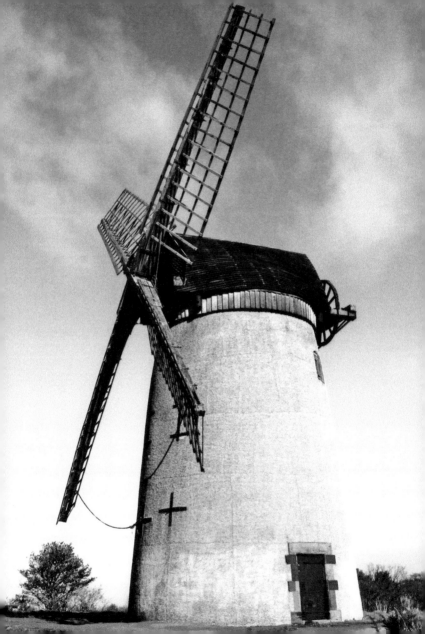

38. WINDMILL, BIDSTON HILL

It is believed that there has been a windmill on Bidston Hill since 1596, and the current building was built around 1800. The windmill operated as a working flour mill until 1875 and after falling into disuse, the windmill and the land on which it stands was purchased by Birkenhead Corporation and restored from 1894. The land, including the woods surrounding the mill, was purchased from R. G. de Grey Vyner during the years 1894 to 1908 at a cost of £30,310. Birkenhead Corporation contributed £14,625 and £15,685 was raised by public subscription. According to the deeds of conveyance the land must always be used as an open space and place of public recreation and must be preserved and maintained in its present wild and natural condition.

39. THE BIDSTON OBSERVATORY

The Bidston Observatory was the home of the Institute of Coastal Oceanography and Tides, which was founded in 1843. The observatory was transferred to the site in Bidston in 1864 where astronomical and meteorological observations were continued under the aegis of the newly formed Mersey Docks and Harbour Board. Tidal predictions were prepared at Bidston for more than half the major ports in the world and work was carried out on tidal streams, non-tidal currents, surface waves and other processes of tidal circulation and mixing. However, the institute moved from the site at Bidston to Liverpool University in 2003 and the Grade II listed building was advertised for sale.

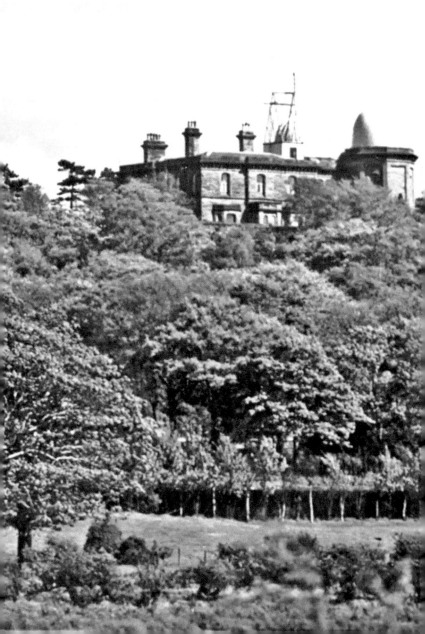

40. TAM O' SHANTER COTTAGE AND FARM

Tam O' Shanter Cottage and Farm, Bidston, is an urban farm run by a charitable trust with the aim of providing an enjoyable and educational experience for young people. It is home to a variety of farm animals including pigs, sheep, goats, chickens and geese, and is an opportunity for children of all ages to meet and learn about farm animals up close.

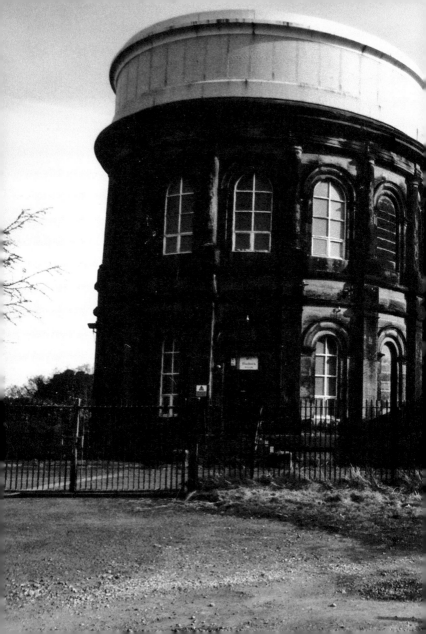

41. WATERWORKS AND RESERVOIR, BIDSTON

The water tower was built of squared sandstone and is a Grade II listed building.

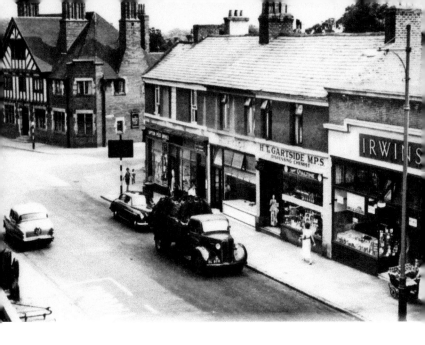

42. UPTON VILLAGE LOOKING TOWARDS BIRKENHEAD

In the middle of the nineteenth century a weekly market was held at Upton. Fairs were held twice a year, on the last Friday in April and on the Friday before Michaelmas. The town became part of the County Borough of Birkenhead in 1933.

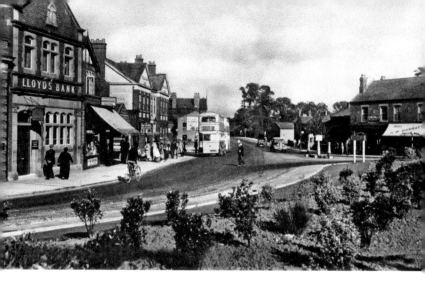

43. MORETON CROSS AND BIRKENHEAD ROAD AT MORETON, 1950

The Coach & Horses at Moreton replaced the previous hotel, which was demolished and the road was widened.

44. LADY LEVER ART GALLERY, PORT SUNLIGHT

Lady Lever Art Gallery, Port Sunlight, was opened by Princess Beatrice. The Prince of Wales (later King Edward VIII) visited in 1931 and the Duke of York (later King George VI) opened a group of cottages that bear his name in 1934.

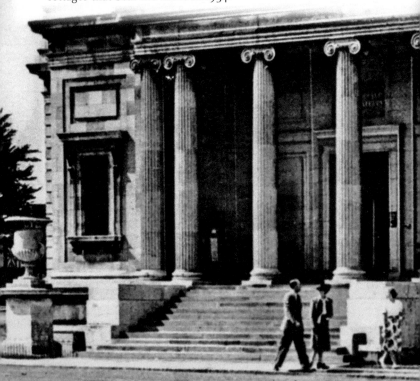

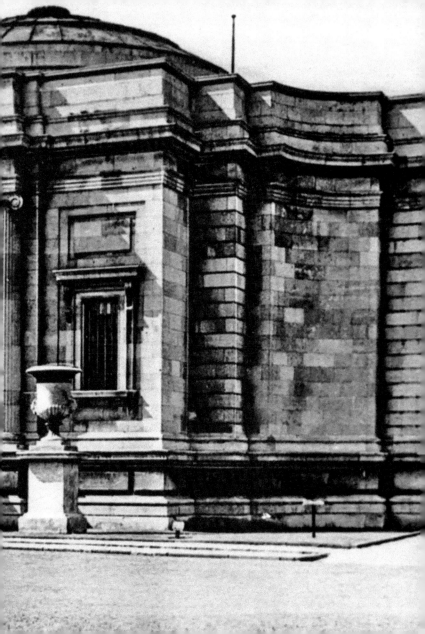

45. LEVER BROTHERS OFFICES AND WORKS, PORT SUNLIGHT

Port Sunlight was chosen by William Lever for his works as it was ideally placed with its road, rail and water links. The first factory was opened in 1889, followed by the construction of the first cottages two years later. The original village was completed by 1897.

Lever had built 890 houses at Port Sunlight at the time of his death in 1925 and was responsible for the construction and provision of a number of important community buildings. Gladstone Hall, Hulme Hall, the Bridge Inn, the Gymnasium, Open Air Swimming Baths, the Girls' Club and Cottage Hospital and other community-based facilities were provided for the use of people living in the village. The company merged with the Dutch company Margarine Unie in 1930 to form Unilever, and Port Sunlight was placed under the management of Unilever Merseyside Ltd in 1960, becoming UML Ltd in 1968. The village was declared a conservation area in 1978 and in 1980 the houses became available for the tenants to purchase.

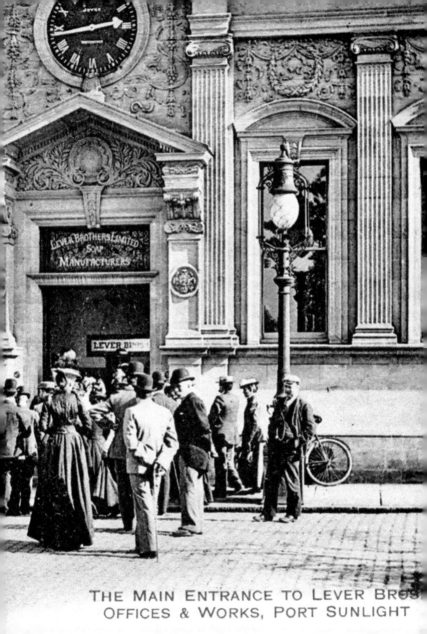

LEVER BROTHERS LIMITED
SOAP
MANUFACTURERS

LEVER B...

THE MAIN ENTRANCE TO LEVER BROS
OFFICES & WORKS, PORT SUNLIGHT

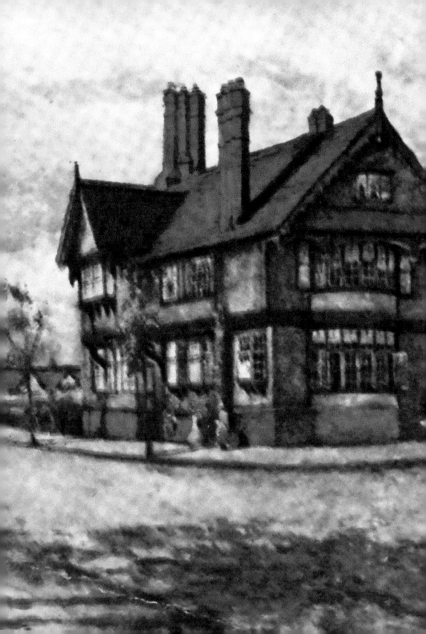

46. BRIDGE INN, PORT SUNLIGHT

The Bridge Inn was opened in 1900 as a temperance pub. Lever was a lifelong teetotaller. However, within two years, following a local referendum it became a licenced public house.

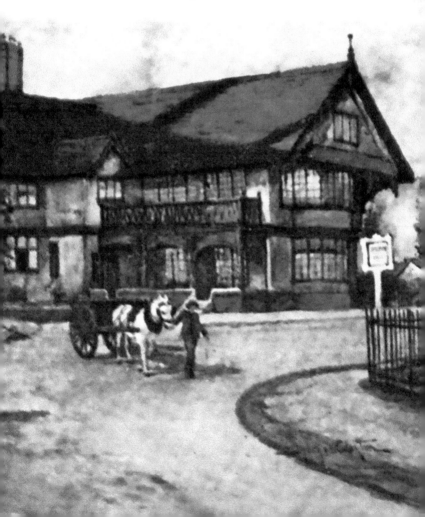

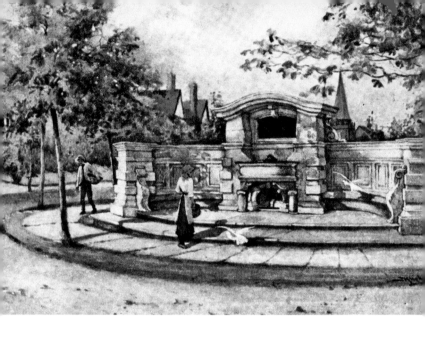

47. PORT SUNLIGHT VILLAGE FOUNTAIN

The village fountain was one of the features provided for the people living in Port Sunlight.